Peter Paul Rubens

Claudia Bauer

D0369996

Prestel

Munich • Berlin • London • New York

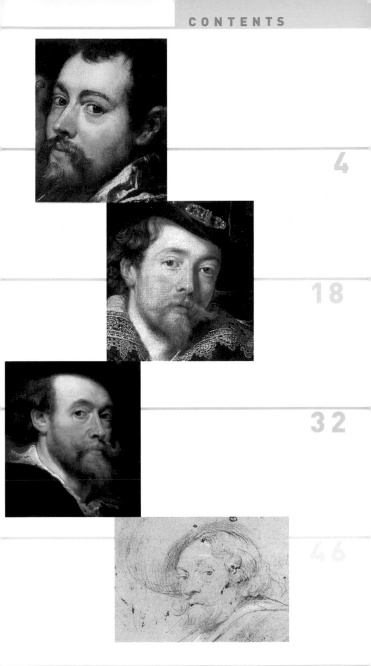

The Road to Success

The work of Peter Paul Rubens is considered the epitome of Flemish Baroque. His artistic talent and diplomatic skills brought him international fame even in his lifetime, opening the doors of palaces and aristocratic houses. Rubens was not just an artist. Like no other, he embodied the ideal of the universal man. A cosmopolitan and art collector, he trod the political stage with a sure footing, ran a flourishing studio and founded a large family.

His humble beginnings would seem to belie the meteoric rise that took him to the very pinnacle of artistic success in his day. His family roots lay in the busy port and city of Antwerp, which in the first half of the sixteenth century was in its heyday as a commercial centre and important crossroads between northern and southern Europe. His father, Jan Rubens, trained in law and held an important position in the municipal courts, while his mother, Maria Pypenlinckx, came from a prosperous family that played an active part in city affairs.

Religious conflict in the Netherlands _ The two married in Antwerp in 1561 and soon had four children in quick succession. Their bliss was short-lived, however. In 1568, they fled to neighbouring Germany to escape the religious conflicts that plagued the Netherlands. They settled in Cologne, where Jan Rubens obtained employment as secretary and adviser to Anne of Saxony, the wife of William of Orange.

When Anne went to Siegen, Westphalia, in 1570, the Rubens family followed her. Shortly thereafter, Jan Rubens' affair with her became known and he was arrested for adultery. Despite this humiliation, Maria Pypenlinckx fought for her husband's freedom and, after long negotiations, her efforts were rewarded.

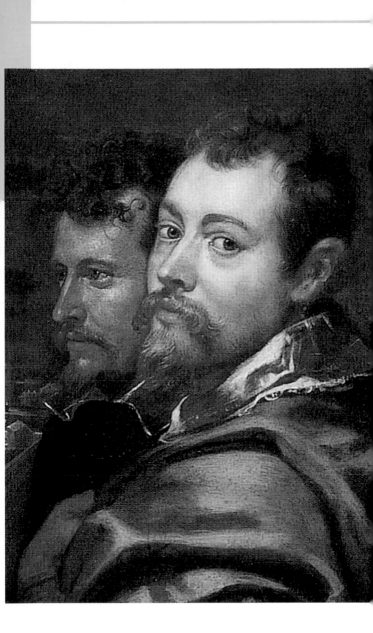

Success comes his way

Rubens among his Mantuan Friends (detail), *c.* 1602. oil on canvas, 77.5 × 101 cm,
Wallraf-Richartz Museum, Cologne

Birth and childhood in exile _ In 1573, Philipp was born, followed four years later, on 28 June 1577, by a younger brother, Peter Paul. The following year, in considerable financial straits, the family left Siegen and returned to Cologne, where Jan Rubens died in 1587. Though he and his wife were never avowed Protestants, the flight from Antwerp to Germany suggests that they did subscribe to the Calvinism that prevailed in Holland.

Nonetheless, Jan Rubens officially became a Catholic before his death, probably because in Catholic Cologne anti-Protestant feeling was also on the rise. In 1589, Maria Pypenlinckx turned her back on

The commercial city of Antwerp in Rubens' day

Hans Bol, **Prospect of Antwerp** (detail), 1583, tempera on parchment on panel, 5.9 × 23 cm, Haboldt & Co., Paris

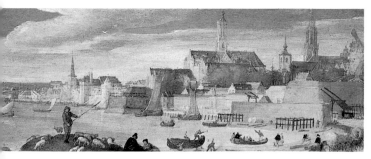

His most important teacher

Otto van Veen (1556–1629), **Self-portrait with Family**, 1584, oil on canvas, 176 × 250 cm, Musée du Louvre, Paris

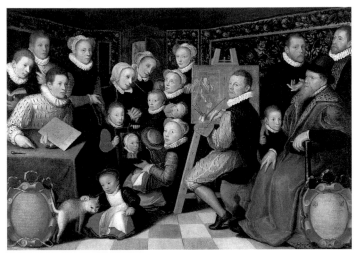

Cologne and returned to her native Antwerp with her children. The first decade or so of Peter Paul's life was thus marred by the insecurity of life in exile, family problems and violent religious conflict. This background may explain his later diplomatic commitment, his role as the most influential painter of the Counter-Reformation and the great importance he placed on his own family.

Lessons with Otto van Veen _ In Antwerp, Rubens went to the school of Rombout Verdonck, where he was taught Greek and Latin and versed in the classics. In 1591, his mother obtained him a post as a page in an aristocratic household near Brussels. The youthful Rubens found little pleasure in this activity and made his escape after only a year – he was allowed to commence training in a painter's studio. He began to take lessons with the rather undistinguished landscape painter Tobias Verhaecht, soon changed to Adam van Noort and ended up with his most important teacher, Otto van Veen. His apprenticeship came to an end in 1598, when he joined the Guild of St Luke. Few known works from this early period survive. Paintings such as the *Portrait of a Man* of 1597 or *Adam and Eve* of c. 1598–1600 (both p. 8) show, however, that initially he stuck rather closely to earlier models,

Portrait of a Man (probably an architect) 1597, oil on copper, 21.6 × 14.6 cm, The Metropolitan Museum of Art, New York

Adam and Eve, c. 1598–1600, oil on panel, 180.3 × 158.8 cm, Rubenshuis, Antwerp

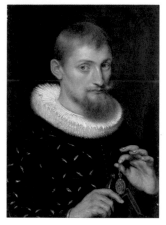
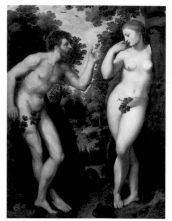

preferring clear lines. There is still little evidence of the flowing baroque forms and differentiated surfaces that were characteristic features of his later work.

Journey to Italy _ In May 1600, Rubens set off for Italy. He was thus following a path well-trodden by northern European painters looking for a source of inspiration for their own artistic development – Otto van Veen had also spent a number of years south of the Alps.

Titian (c. 1485/1490–1576) _ whose real name was Tiziano Vecellio, was one of the greatest painters of the Italian Renaissance. He went to Venice to train with the Bellini brothers, and in his early work was influenced by Giorgione. However, he soon found a style of his own that was wholly colour-driven. His triumphal altarpieces, psychological portraits and dramatically composed mythological scenes set new standards. With his portraits of Emperor Charles V, Titian's work was in demand internationally even in his lifetime, and his paintings soon found their way into major art collections.

Rubens in the Service of the Duke of Mantua – His first stop was Venice, where he encountered paintings by Paolo Veronese, Tintoretto and Titian. Especially the latter's works and his handling of colour would strongly influence Rubens all his life. Good contacts led him to the court of Duke Vincenzo Gonzaga in Mantua, who appointed him court painter.

Studies Classical Art in Rome – In 1601, Rubens travelled with the duke's permission to Rome, where he embarked on the study of Classical sculpture, the works of great Renaissance artists, such as Raphael and Michelangelo, and contemporaries working there, such as Caravaggio or the German painter Adam Elsheimer. Numerous sketches and drawings, for example his study of *c.* 1601/02 based on the Greek statue of an African fisherman, provide ample testimony of this. The Classical sculptures and their resonance in the art of the Renaissance must have influenced Rubens deeply. Time and again we find in his later works elements of what he saw during his time in Italy.

An object of study – classical sculpture

African Fisherman (or The Dying Seneca), *c.* 1601/02, black chalk, 46 × 32 cm, Hermitage, St Petersburg

African Fisherman (or The Dying Seneca), marble with enamelled eyes and belt of alabaster, height 118.4 cm, Musée du Louvre, Paris

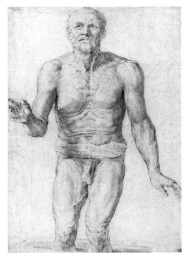 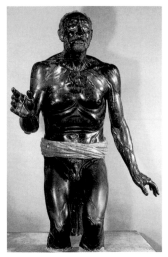

The Fight for the Standard, from the Battle of Anghiari, 1600–1608, black chalk,
pen and ink with brown wash, heightened with white and grey, 45.2 × 63.7 cm,
Musée du Louvre, Paris

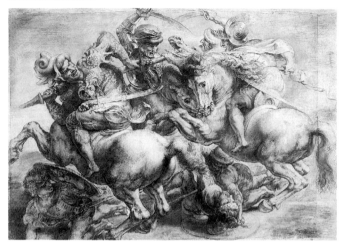

Rubens and the Renaissance _ Part of the same Italian experience
can be deduced from a drawing he made in 1600–1608 after Leonardo
da Vinci's unfinished fresco the *Battle of Anghiari*, which was original-
ly in the Palazzo della Signoria in Florence and was already overpaint-
ed by the sixteenth century. Rubens must therefore have worked
from a Leonardo cartoon since lost or from an engraving. As so often,
Rubens went far beyond mere emulation. Instead, his aim was to cap-
ture the composition and dynamics of the scene. The study is generally
considered a preparatory drawing for the great hunting scenes of
Rubens' later work.

The Flemish master's gift did not go unnoticed and even before he
returned to Mantua, he was commissioned to produce an altarpiece
for a church in Rome. In 1602, he was back at the Gonzaga court. The
same summer, he met his brother Philipp in Verona. As a scholar,
Philipp was also planning a lengthy stay in Italy. The painting *Rubens
among his Mantuan Friends* dates from this period and includes the
artist's first self-portrait. It shows Rubens together with his brother
and the latter's teacher Justus Lipsius, plus three other, as yet uniden-
tified men.

The Spanish Court _ His engaging personality must have made a particular impression on Vincenzo Gonzago, because the duke asked Rubens to undertake a journey to the Spanish court to deliver presents to Philip III, successor to Philip II. The aim was to promote the interest of the small duchy of Mantua at the Spanish court. By the time Rubens arrived in Valladolid in 1603, after a short stop in Madrid, the king had removed with his retinue to Burgos. Rubens used the time until the household returned to examine the extensive royal art collection.

> "... *so many splendid works in the royal palace, the Escorial and elsewhere, by Titian, Raphael and others, which astonish me with their high quality as well as their sheer number* ..."
> Rubens to Annibale Chieppio, Vincenzo Gonzaga's state secretary, 1603

That Rubens already enjoyed considerable fame as a painter even in Italy had not yet filtered through to Spain. However, the Duke of

The artist's first self-portrait

Rubens among his Mantuan Friends, *c.* 1602, oil on canvas, 77.5 × 101 cm, Wallraf-Richartz Museum, Cologne

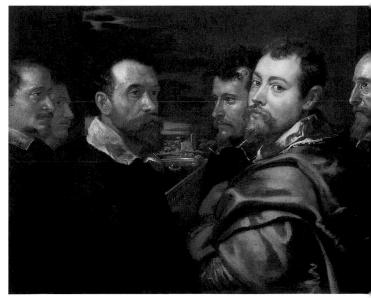

Equestrian Portrait of the Duke of Lerma, 1603, oil on canvas, 289 × 205 cm, Museo del Prado, Madrid

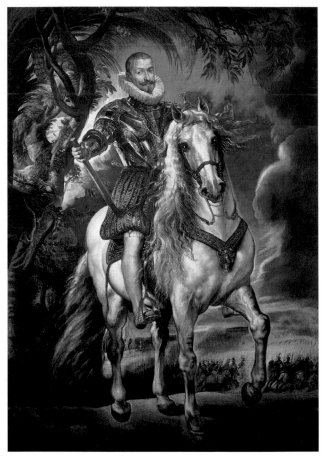

Lerma, the king's influential prime minister, soon recognized his guest's consummate skill and commissioned a portrait from him. Rubens depicted the duke, who was generally treated as the real regent of the Habsburg empire, in a monumental equestrian painting. The idea for this may have come from Titian's equestrian portrait of Charles V, Philip III's grandfather, which Rubens had seen in the royal art collection.

Ad gloriam dei – a very human attempt to document his mended ways

The Holy Trinity Adored by the Gonzaga Family, *c.* 1604–06, oil on canvas, 190 × 250 cm, Accademia, Mantua

Returns to the Netherlands _ Rubens soon left Spain to return to the Gonzaga court, where he worked on the altarpiece for the Jesuit church in Mantua, *The Holy Trinity Adored by the Gonzaga Family*, which has not survived complete. What stands out is Rubens' similar compositional approach and handling of colour to contemporary Venetian artists, particularly Veronese and Tintoretto.

At the end of 1605, Rubens was drawn to Rome again, where he met his brother and Adam Elsheimer and worked on new commissions. In autumn 1608, news reached him that his mother was on her deathbed. Although he set off for Antwerp without delay, he failed to arrive in time. Maria Pypenlinckx died on 10 October, 1608.

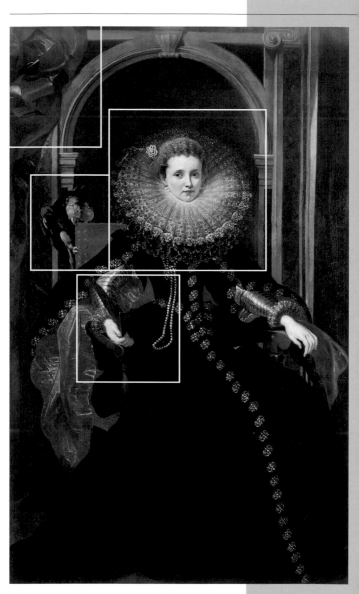

Veronica Spinola Doria, *c.* 1606–07, oil on canvas,
225 × 138 cm, Staatliche Kunsthalle, Karlsruhe

Marchesa Veronica Spinola Doria

A glimpse of the cream of Genoese society — Rubens reinvents the portrait

Rubens did not return directly to Mantua from the Spanish court, finding time for a short stay in Genoa first. It was a place he returned to later several times to carry out commissions for a number of 'outstanding personalities' with whom he was (as he wrote in a letter) 'on a very familiar footing'. He painted a series of portraits of aristocrats that now gives us a vivid picture of Genoese society at the time.

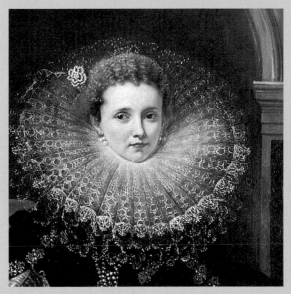

Rubens appears to have been particularly well connected with members of the Doria family, because three portraits of them survive. One shows the young Marchesa Veronica Spinola Doria lifesize, sitting opposite us on a chair upholstered with red velvet. She wears an opulent black robe with a ruff of the finest lace, which frames her youthful face like an aureole. The red carnation in her carefully curled hair echoes the colour of the chair. In Rubens' day, Genoa was an independent republic. Close connections with the Spanish crown resulting from the Genoese bankers' role as financial representatives of Spain ensured Genoa

political protection and amply filled coffers. The links with the Habsburg court were evident not least in fashion. Elegant Genoese ladies like Veronica Spinola Doria preferred Spanish materials and styles. The showy but undoubtedly rather uncomfortable ruff counted as a

desirable status symbol in the second half of the sixteenth century and was also worn by men, as the equestrian picture of the Duke of Lerma or the early *Portrait of a Man* by Rubens proves. The lace used in these, which was pressed into shape with a branding iron or a wire frame, not infrequently came from the southern provinces of the Netherlands. Brussels, Mechelen and even the Rubens family's home town of Antwerp were considered the leading production centres. The Marchesa's precious pearl jewellery and the open fan she holds in her right hand are further indications of her wealth.

The arch of the niche behind her surrounds her upper body and, in conjunction with the austere architectural articulation of the wall, underlines the atmosphere of grandeur in her portrait. The clear shapes also form an interesting contrast with the opulently folded sleeves of her robe and length of material draped in the top left corner.

Rubens chose the palette for his picture quite deliberately. Gold, silver and red are the armorial colours of the Spinola dynasty, the name that Veronica bore before her marriage into the Doria family. The trio of colours occurs in the interplay of dress and chair upholstery, in the feathers of the exotic parrot, which is nibbling the back of the chair, and finally in the gathered curtain top left.

The portrait of Veronica's sister-in-law, the beautiful Marchesa Brigida Spinola Doria, is just as masterly. She is dressed as splendidly as Veronica and seems to be calmly strolling past us in front of a magnificent architectural setting. Unfortunately the painting was later heavily trimmed, which rather spoils its effect. In both portraits, Rubens succeeded in walking the difficult tightrope between grandiosity of style befitting the subjects' rank and fresh, lively pictures of young women. There is no trace here of the stiff, almost ossified-looking aristocrats of many Renaissance-period paintings. With this new approach to portraiture, Rubens paved the way for contemporary and later portrait painters, such as Anthony van Dyck and Sir Joshua Reynolds.

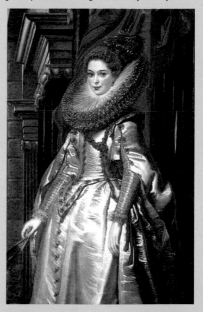

Marchesa Brigida Spinola Doria, c. 1606, oil on canvas, 155.2 × 98.7 cm, National Gallery of Art, Washington D.C.

The Most Sought-after Painter in Antwerp

Back in Antwerp, Rubens toyed with the idea of setting off for Italy again, where he had just begun to gain a foothold. However, the cordiality of his reception in his homeland and the many opportunities afforded him there soon led him to abandon the plan. In 1598, Philip II of Spain had put his favourite daughter, Isabella, and her husband, Archduke Albert, in charge of the Spanish Netherlands. Based in Brussels, the couple ruled with a light touch and for a while the war-scarred southern provinces enjoyed a period of economic and cultural prosperity. Under the Counter-Reformation, churches stripped bare by Protestant zealots were refurbished with even greater splendour. Work for artists abounded.

Rubens in the Service of the Spanish Court in Brussels _
Albert and Isabella asked Rubens to become their court painter. With the memory of the intrigue-ridden, narrow-minded atmosphere of the courts in Mantua and Spain still fresh in his mind, Rubens initially reacted with reluctance:

> *"The Archduke and Her Most Serene Highness the Infanta sent me word pressing me with great insistence to enter their service on most excellent terms, although I feel little desire to embark on the life of a courtier again."*
> Rubens to Johann Faber, 1609

In the end, the 'excellent terms' proved persuasive. Although the court was in Brussels, he could remain in Antwerp, was not required

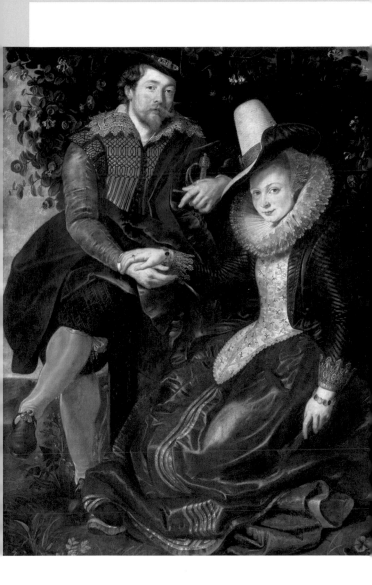

The self-confident artist

Rubens and Isabella Brant in the Honeysuckle Arbour, *c.* 1609/10, oil on canvas,
179 × 136 cm, Alte Pinakothek, Munich

to conform to the strict conditions of the painters' guild and was even allowed to take pupils. His brother Philipp also returned to Antwerp to take up the post of municipal secretary and married there shortly afterwards.

Marriage to Isabella Brant _ Only a few months later, on 3 October, 1609, Rubens himself stood at the altar alongside eighteen-year-old Isabella Brant, daughter of a highly regarded family. Her father, Jan Brant, held a similar position to Philipp Rubens and was an educated man who devoted his spare time to scholarship and classical literature. *Rubens and Isabella Brant in the Honeysuckle Arbour* probably dates from the same year. It shows the young couple against the backdrop of a flowering shrub, which has been a symbol of marital love since the Middle Ages. The full-length portrait and natural poses of the newly-weds clearly sets the scene apart from traditional wedding and engagement pictures of the day, which often took the form of small-scale bust portraits and were executed primarily for documentation purposes. After the wedding, Rubens and Isabella lived with Jan Brant, but by the end of 1610 they had bought a splendid property not

The home of the artist's family

Jacob Harrewijn, after Jacob van Croes, **The Family Home in Antwerp**, 1692, engraving, 33 × 43.5 cm, Rubenshuis, Antwerp

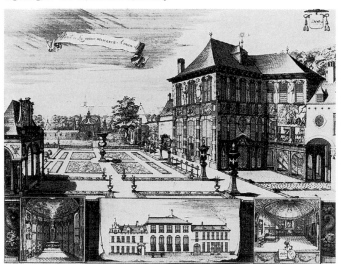

Nothing is left to chance – the result is painterly perfection

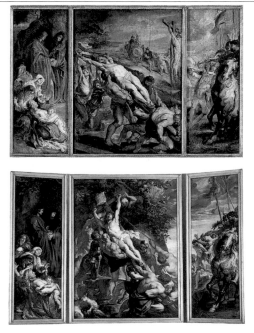

Sketch for the Raising
of the Cross, *c.* 1610,
oil on panel, 68 × 101 cm,
Musée du Louvre, Paris

Raising of the Cross,
1610–11, oil on panel,
462 × 641 cm, Antwerp
Cathedral

far from the Meir, a main thoroughfare of Antwerp. They moved into it
in 1615, after building work had been completed.

**The Counter-Reformation brings numerous commissions for
Antwerp churches** _ Rubens was now comfortably off thanks to the
great demand for his work. Along with important commissions, such as
the Antwerp Town Hall, he was asked in 1610 to do a painting for the
high altar of the Gothic church of St Walpurga's. The church council
wanted a large triptych that would serve as the focal point of the
entire church. The main scene, visible when the altarpiece is open,
shows the *Raising of the Cross*. It was already evident in a prepara-
tory oil painting that Rubens intended to ignore the tripartite division
of the altarpiece and carry the scene over on to the wings. The final
version betrays an Italian influence. The masterly play of chiaroscuro
recalls the work of Caravaggio, while the vigorous physicality of the
soldiers and their well-composed, dramatic poses are reminiscent of
Classical sculpture such as Rubens studied in Rome. Here he was

already revealing himself as a painter of flesh, sensuousness and vitality, who made no distinction between religious and secular subjects.

Shortly after the completion of the *Raising of the Cross*, the Antwerp Guild of Archers commissioned Rubens to design an altarpiece for their chapel in the cathedral. Once again Rubens' work had to

Holy figures as real people

Descent from the Cross, 1611–14, oil on panel, 420 × 610 cm, Antwerp Cathedral

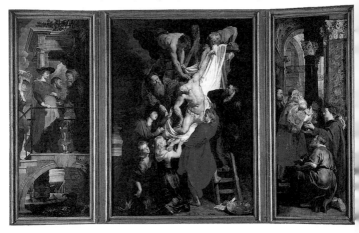

take the form of a triptych, with the *Descent from the Cross* in the middle, the *Visitation* on the left wing and the *Offering in the Temple* on the right. The composition focuses entirely on a sliding, downward movement and interweaving of the figures, and served Rembrandt, Rubens' great counterpart from the Protestant northern provinces of the Netherlands, as a source of inspiration for his painting of the same subject *c.* 1633.

The studio prospers _ With these two altarpieces, Rubens finally established himself as a respected artist. His studio grew and an apprenticeship in his workhouse became very desirable indeed among young artists:

> *"I can honestly say without exaggeration that I have had to turn away over a hundred pupils, even some of my own or my wife's relations, not without having given rise to very great displeasure among some of my best friends."*
> Rubens to Jacob de Bie, 1611

A strict hierarchy and clear division of labour prevailed in the large studio Rubens ran. Duties ranged from mixing pigments via preparing canvases to making copies of works already finished, for which there was a constant market. Moreover, engravings of many paintings were commissioned and sold. Rubens prepared important commissions not just with drawings and studies but also with preliminary oil paintings of the composition – as with the *Raising of the Cross* – which he used to discuss the project with the client concerned. These were subsequently transferred to and completed on canvas (generally by an assistant).

Not infrequently, the execution of paintings based on compositions by Rubens was done entirely by assistants, with only the final touches being given by the master personally. Pictures painted exclusively by Rubens fetched much higher prices. Among the most skilled employees in Rubens' studio was van Dyck, who later gained fame at the English court.

Anthony van Dyck (1599–1641) _ Born in Antwerp, van Dyck was taught in his early years by Hendrik van Balen (1575–1632), but was then taken on in Rubens' studio, where he worked with the great artist on such major commissions as the ceiling paintings for the Jesuit church in Antwerp. After a short spell in England, he went to Italy and immersed himself in Titian's work. In 1632, he returned to London and was appointed court painter to Charles I. He became famous principally for his sensitive portraits, which set a benchmark for portraiture in the Baroque period.

Death of his beloved Brother Philipp _ In 1611, the Rubens had their first child, daughter Clara Serena. Two sons, Albert and Nicolaes, followed in 1614 and 1618, respectively. This private happiness was overshadowed by the untimely death of his elder brother Philipp Rubens, to whom Peter Paul had been very close. His family was the painter's great pride, as a series of drawings of his children bears out, probably done in a domestic environment.

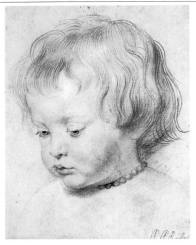

Boy with a Coral Necklace, possibly Rubens' son Nicolaes, *c.* 1619, black and red chalk, heightened in white, 25.2 × 20.2 cm, Albertina, Vienna

First pictures on mythological subjects _ With the Counter-Reformation in full swing, there was great demand for religious paintings, but Rubens also painted numerous pictures of mythological scenes. In Catholic Flanders, the ideals of the Classical world

Belated use of a sketch from his time in Rome

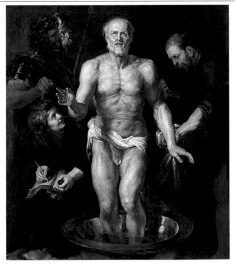

The Dying Seneca, *c.* 1612–14, oil on panel, 185 × 154.7 cm, Alte Pinakothek, Munich

rediscovered since the Renaissance ranked highly, since parallels of
content were often drawn with Christian doctrine. The painting *The
Dying Seneca*, dating from around 1612/14, should be seen in this con-
text. Based on studies that Rubens made of a Hellenistic figure in
Rome, it depicts the Roman philosopher Seneca, who was forced by
the Emperor Nero to commit suicide on trumped-up charges. A beard-
ed man cuts the victim's arteries, who stands in a bowl of hot water to
hasten the flow of blood. Seneca's fate is generally seen as prefiguring

Sensuality and eroticism in mythological guise

Rape of the Leucippides, *c.* 1618, oil on canvas, 224 × 210.5 cm,
Alte Pinakothek, Munich

Samson and Delilah, *c.* 1609, oil on panel, 185 × 205 cm, National Gallery, London

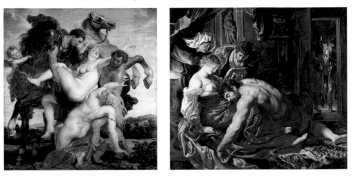

Christ's martyrdom. For Rubens, the picture has a further level of
meaning. Seneca is considered the most important representative of
Stoicism, a philosophy that enjoyed a revival in Rubens' day. His
brother Philipp, who probably died before the picture was painted,
was taught by Justus Lipsius, a major exponent of Stoic philosophy of
the day.

Rubens' particular ability to capture people in all their physicality
on canvas also led to a series of commissions of a more private nature.
Despite the mythological or religious settings, which met the client's
requirement for intellectual respectability, it was above all their erotic
elements that made paintings by Rubens objects of desire within the
four walls of the home. Works such as the *Rape of the Leucippides* of
c. 1618 or the representation of *Samson and Delilah*, which Rubens
painted around 1609 for the Antwerp city councillor Nicolaas Rockox,

Great Last Judgement, after 1614, oil on canvas, 606 × 460 cm,
Alte Pinakothek, Munich

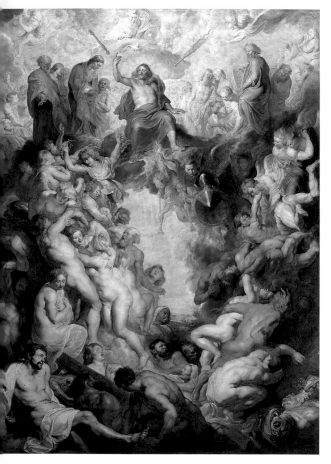

impress not only because of their intricate compositions and brilliant
colours but also their sensuality. Not that the naked bodies that
Rubens painted always encountered unalloyed enthusiasm. The *Great
Last Judgement*, painted in 1614/16 at the behest of Duke Wolfgang
Wilhelm of the Palatinate-Neuburg as an altarpiece for the Jesuit
church in Neuburg an der Donau, was removed from the premises
in 1653 because of its 'indecent nudities'.

Hunting scenes arouse princes' interest in Rubens _ Rubens now turned his hand to the genre of hunting scenes, having discovered that these were highly popular among princely collectors. Passionate about hunting, they liked to decorate their palaces with such scenes. But Rubens went one step further. Along with fox-hunting or pursuits of wolves and wild boar, he also painted archaic combats between men and exotic creatures, such as lions, hippos and crocodiles – dramatic scenes that have nothing in common with traditional hunting and are more like battle scenes.

In 1615, the Jesuits in Antwerp built a church of their own. Rubens was called in to design not only a number of altarpiece frames and the two pictures for the high altar but also to do sketches for the sculptural furnishings. In 1620, he signed a contract promising to paint thirty-nine compositions for the ceilings of the aisles. Alas, the finished products were destroyed by fire in 1718, so that we have only the surviving sketches as a record of their former glory.

Hardly a typical hunting scene!

Hunting Hippos and Crocodiles, _c._ 1616, oil on canvas, 248 × 321 cm, Alte Pinakothek, Munich

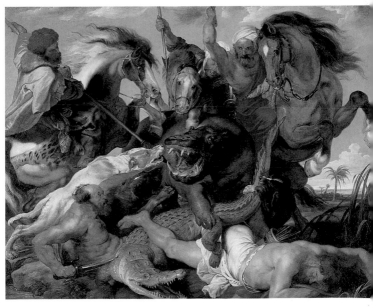

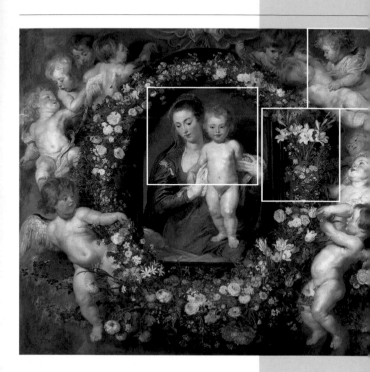

Peter Paul Rubens and Jan Brueghel the Elder (1568–1625),
Madonna in the Floral Wreath, *c.* 1620, oil on panel,
185 × 209.8 cm, Alte Pinakothek, Munich

Madonna in the Floral Wreath

The miracle-working picture with the personal touch — Rubens as a collaborative painter

Rubens worked not only with pupils and assistants in his studio but from time to time also with established fellow painters. These were always the best specialists in their fields. They included select landscape painters, such as Cornelis Saftleven, still-life painter Osias Beert the Elder and animal painter Frans Snyders. Collaboration of this kind was not uncommon in seventeenth-century Flemish painting, and indeed was standard practice in the larger studios.

Rubens was not only on professional terms but also friends with Jan Brueghel the Elder (1568–1625), second son of the celebrated Pieter Bruegel the Elder. This is borne out by a sensitive portrait of Jan Brueghel and his family that Rubens painted *c.* 1612/13. Though famous for his small landscapes and multifigure history paintings, the younger Brueghel's real forte was flower pictures.

He and Rubens worked together *c.* 1617/20 on the *Madonna in the Floral Wreath*, which is a 'picture within a picture'. The centre com-prises a self-con-

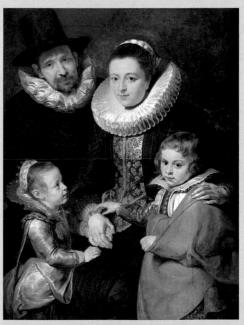

Jan Brueghel the Elder and his Family, *c.* 1612/13, oil on panel, 124.5 × 94.6 cm, Courtauld Institute Galleries, London

tained image of the Madonna presenting her Son. Around them is a painted frame in the form of a colourful floral wreath held up by a host of putti. Attached to a stone cartouche with a pink band, the frame almost resembles a window through which Mother and Son look out on the world. In his formulation of the Madonna and Child, Rubens' portrayal makes the Virgin look less like a venerable saint than a solicitous mother who has just put her child on her knee. The two figures are rendered in so lifelike a way that we get the impression they are coming towards us out of the picture.

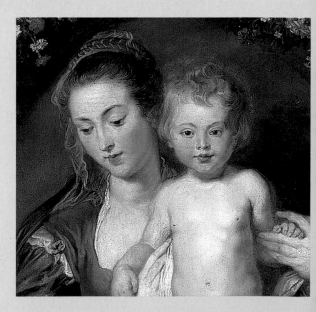

The consensus among scholars today is that the features of the Virgin represent those of the artist's wife Isabella, which lends the picture an intimate quality. Their sons Albert and Nicolaes also appear in the painting. The Christ and the putto seen in profile in the top right corner

resemble drawings that Rubens did of his children. These observations are interesting in that, though Rubens often drew members of his family by Isabella and constantly reused these studies as a basis for his compositions, he never executed a family portrait as such.

The wreath by Jan Brueghel comprises hundreds of colourful flowers, each painstakingly rendered in all their decorative splendour. But beneath all the prettiness lies a reference to medieval flower symbolism. Lilies, for example, stood for virginity and innocence, and were therefore often associated with the Virgin; roses, tulips and hollyhocks were also symbols of her.

The collaboration between Rubens and his friend Jan Brueghel had begun before Rubens went to Italy. Even in Otto van Veen's studio, the two worked together closely with Veen on a now-lost picture of Parnassus, the *Realm of Poetry*. Moreover, Rubens collected works by Brueghel's father, Pieter, who acquired fame with his keenly observed scenes of peasant life. The bond between the two friends was reinforced by their joint travels, and after Jan Brueghel's premature death in 1625 Rubens became his children's guardian. Some of the paintings on which they collaborated remained in his possession, an indication of how highly Rubens valued them.

From the Artist's Studio to the Political Stage

Marie de' Medici commissions an extensive series of paintings —
Devastation throughout northern Europe — Death of Clara
Serena and Isabella Rubens — On diplomatic mission for the
Spanish Court

Marie de' Medici commissions an extensive series of paintings — Following the completion of his magnum opus for the Jesuits, Rubens did not have to wait long for another mammoth commission. In 1621, the artist was approached by Marie de' Medici, the dowager-queen of France, who wanted him to furnish paintings for her new Palais du Luxembourg in Paris. Commenced 1615 by architect Salomon de Brosse, the palace contained two long galleries. The western one was to contain twenty-one pictures with the life of the patroness in addition to three portraits, while the eastern one would have a similar arrangement to glorify her deceased husband, Henry IV.

Rubens duly went to Paris and in February 1622 signed a contract for the two series. He undertook to do all the figures personally, leaving only backgrounds and small details to his assistants. It was a project that required all the tact Rubens possessed. He was aware that the job meant more than just painting decorative pictures. The real task was to depict the dowager in a positive, indeed brilliant light, i. e. the paintings were to be a political statement. Marie de' Medici's position at the French court was precarious. Her difficult relationship with her son, Louis XIII, and the rumours of her involvement in the death of Henry IV made the choice of subject matter a thorny business. Rubens deftly avoided the risk of choosing the wrong subjects and upsetting either the dowager or Louis XIII by adopting an altogether ingenious approach. Instead of depicting individual episodes from the queen's life in a realistic, historically accurate way, he opted for a different level of narrative. He transformed the various scenes into allegories, introduced mythological figures, personifications of vices and

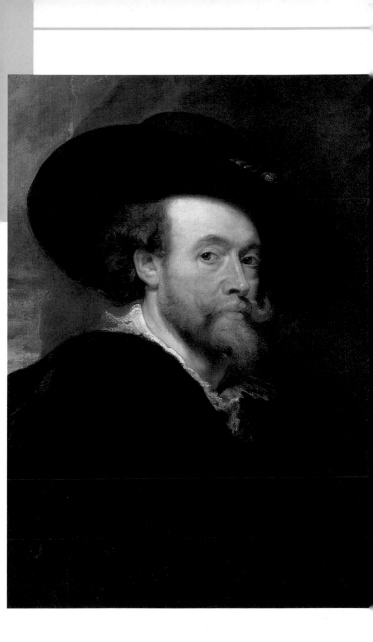

The mature artist

Self-portrait, *c.* 1623/24, oil on panel, 86 × 62.5 cm, The Royal Collection,
Windsor Castle

virtues or symbolic allusions to avoid details or explicit references and leave room for interpretation. When the contract was signed, the first subjects were already agreed upon, and as was usual with major commissions Rubens made preliminary oil paintings. Among the first was *The Princess' Upbringing* (after the birth scene), which contains

A truly princely education

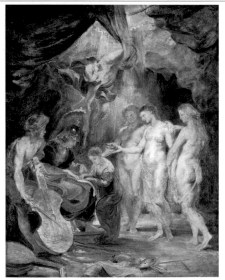

The Princess' Upbringing (sketch for the Medici cycle), 1622–25, oil on oak panel, 49 × 39 cm, Alte Pinakothek, Munich

numerous references to Marie's virtues. Minerva, goddess of peace, wisdom and courage, instructs the young princess, the divine messenger Mercury sweeps down from above and the three Graces crown the future queen. The palette, brush and lute in the foreground allude to her later role as a patron of the arts. Another event included in the series is the *Proxy Marriage of Marie de' Medici and Henry IV* – a magnificent work that depicts what in reality had been a rather sad occasion for the young Marie. On the day of her wedding, the groom was too busy to attend the ceremony in Florence, and so was represented by Ferdinand of Tuscany, Marie's uncle.

A wedding with no groom ... followed later by the first meeting in Lyons

Proxy Marriage of Marie de' Medici and Henry IV, 1622–25, oil on canvas, 394 × 295 cm, Musée du Louvre, Paris

First Encounter of Marie de' Medici and Henry IV, in Lyons, 1622–25, oil on canvas, 394 × 295 cm, Musée du Louvre, Paris

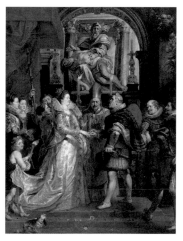
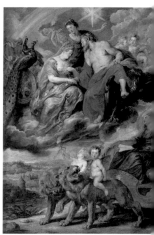

The scene had personal relevance for Rubens. As a young painter newly in the service of Vincenzo Gonzaga, he had been in the latter's retinue at the wedding and witnessed the event. The first meeting of the newly-weds in Lyons was a further humiliation for Marie. Henry appears to have turned up grossly late for this obligatory occasion and showed more interest in his mistress than his wife. Here again Rubens glossed over the reality. The *First Encounter of Marie de' Medici and Henry IV, in Lyons* shows the royal couple under a rainbow, a symbol

of peace and harmony. The pair are clad in Classical robes as the divine couple Jupiter and Juno, an allusion made explicit by the attributes of peacock and eagle. The woman in a splendid chariot drawn by a lion on the right personifies the city of Lyons.

Rubens completed the series in 1624 and personally supervised the installation of the pictures in the Palais du Luxembourg. However, the sequence on the life of Henry IV never got beyond the stage of initial sketches. The explosive atmosphere at the French court, which led to the permanent banishment of Marie from Paris, may possibly be the chief reason for this. In any case, Rubens was working on a commission for Louis XIII parallel to the Medici cycle. It involved cartoons for a series of tapestries featuring scenes from the life of Constantine the Great, which were due to be made by a workshop in Paris founded by Flemish weavers.

Even these huge projects for Marie and Louis XIII did not overtax the Rubens studio. In the first half of the 1620s, a whole series of other works were commissioned, including an altarpiece for the cathedral in Freising, ordered by Veit Adam von Gepeckh, Prince Bishop of the

Louis XIII identified with a hero from antiquity

Constantine's Triumphal Entry into Rome (sketch for the Constantine cycle), 1622, oil on panel, 48.6 × 64.5 cm, Clowes Fund Collection, Indianapolis

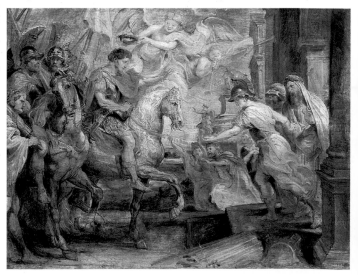

The Triumph of the True Church

Woman of the Apocalypse, 1624/25, oil on canvas, 548 × 365 cm, Alte Pinakothek, Munich

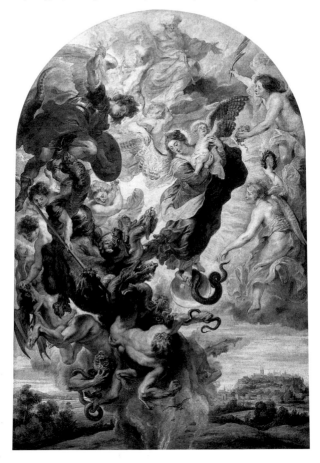

town. The *Woman of the Apocalypse* – whose subject, which is interpreted as Marie, is taken from Revelation – is a vigorous composition in which Rubens depicts the struggle between good and evil with superb chiaroscuro effects.

Devastation throughout northern Europe _ The devastating effects of the Thirty Years' War, aggravating the conflict between the northern and southern provinces of the Netherlands, were becoming more and more evident to Rubens in Antwerp.

Death of Clara Serena and Isabella Rubens _ Fate struck at Rubens even closer to home as well, with the sudden death of his daughter Clara Serena in 1623 and the loss of his beloved wife Isabella in 1626. The presumed last painting he completed of his wife shows her

Isabella Brant as a Mourning Mother

Isabella Brant, c. 1625,
oil on canvas, 85 × 62 cm,
Uffizi, Florence

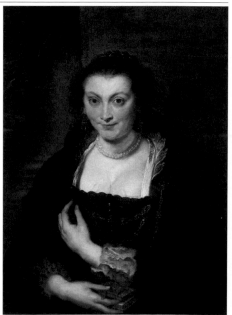

with several vine tendrils in the background, the symbol of eternal love and friendship. Around the same time as the portrait of Isabella, Rubens executed a double portrait of his sons Albert and Nicolaes, which lovingly records the two boys in an informal manner.

Paternal pride shines through

Albert and Nicolaes Rubens, *c.* 1625, oil on panel, 158 × 92 cm, Collection of the Princes of Liechtenstein, Vaduz

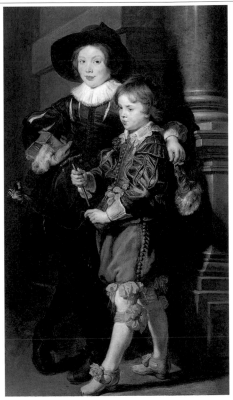

His patroness and confidante, the Archduchess Isabella, sought his help during the political unrest of the day. Ever hopeful of achieving peace, the Habsburg Infanta endeavoured to reconcile Spain and the Dutch northern provinces. As a direct approach proved ineffective, she planned to gain the confidence of the Dutch by forging an alliance with Protestant England, which was well disposed to the Dutch. She wanted Rubens to pave the way for this through his contacts with members of

George Villiers, 1st Duke of Buckingham, 1625, black, red and white chalk, black ink, 38.3 × 26.6 cm, Albertina, Vienna

King Philip IV of Spain, 1628/29, pen and brown ink on black and red chalk, heightened with white, 38.3 × 26.5 cm, Musée Bonnat, Bayonne

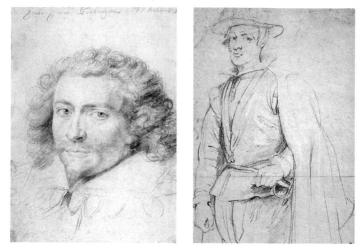

the English court. Rubens was acquainted with George Villiers, the 1st Duke of Buckingham, and a close confidant of Charles I. Villiers was also a passionate art collector, and had had his portrait painted by Rubens several times.

On diplomatic mission for the Spanish Court _ Even in Rubens' day, sending a painter on a political mission was considered an unusual enterprise, yet the very nature of artists' work gave them access to rulers like no one else. Moreover, with his intellectual background and congenial manner, Rubens was well equipped for this subtle kind of diplomacy. Unfortunately, it took a long time for Isabella to convince her nephew Philip IV (the successor to Philip III) of the merits of her plan. At first, Philip disliked the notion of sending 'such an insignificant person' as his representative. But in 1628, he finally summoned Rubens to court in Madrid and, being a great art lover, soon had no further misgivings.

A cursory drawing from Rubens' pen shows the king quite informally with a hat and cape thrown casually over his shoulder, proof of the familiarity between the two. However, when the Duke

of Buckingham, who was to mediate for Rubens at the English court, was murdered that year, the planned venture was put on ice.

Once again, Rubens whiled away the time in Madrid studying the Habsburg art collection, making copies of works by Titian and other artists and by striking up a friendship with the Spanish court painter Diego Velázquez. Finally, in 1629, he travelled to England via Paris and Brussels. The negotiations in London proved difficult, but after three months the two sides had agreed to exchange ambassadors. In April 1630, Rubens returned to Antwerp, disappointed in having to admit that his diplomatic efforts had not been crowned with the desired success. Despite the understanding between England and Spain, the attitude of the northern provinces remained unwaveringly hostile.

Rubens is still inspired by Titian

Diana and Callisto, *c.* 1628/29, oil on canvas, private collection

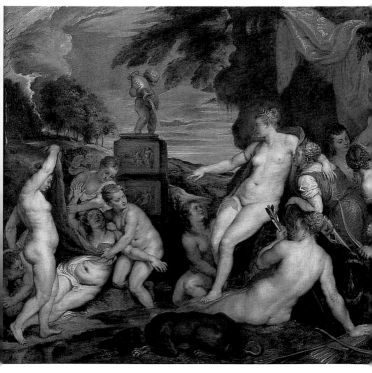

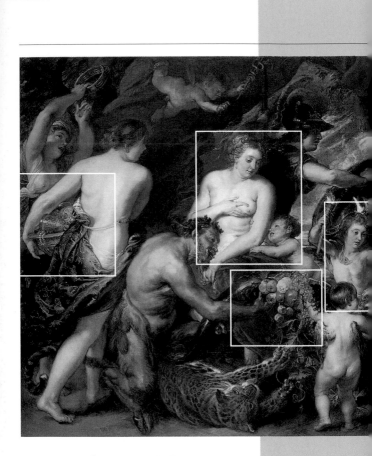

Allegory of Peace (Minerva Protecting Peace
from Mars), 1629/30, oil on canvas, 204 × 298 cm,
National Gallery, London

Allegory of Peace

**A present to the King of England
_ A Rubens painting smoothes
his diplomatic mission**

The time Rubens spent at court in
London was notable not only for
diplomatic negotiations. He was
made welcome by Charles I and,
despite all the political differ-
ences, he and the king established
a cordial relationship. Lauded by
Rubens in a letter as the 'greatest
lover of paintings of all the princes
in the world', Charles I possessed
an impressive art collection, and
was surrounded by distinguished
figures, such as the architect and
stage designer Inigo Jones. In such
circumstances it is astonishing that
Rubens, who was even dubbed a
knight by Charles I, painted no por-
traits of the king. Instead, he pre-
sented his patron with an allegori-
cal picture, the subject of which highlights the purpose of his mission.
Painted between 1629 and 1630, the *Allegory of Peace* is set in the con-
text of the confused political conditions and spreading religious conflict
in Europe. As with the scenes in the Medici cycle in the Palais Luxem-
bourg in Paris, the narrative has nothing to do with reality. It is couched
in mythological terms, whose decoding posed no problems for a cul-
tured connoisseur of art such as Charles – unlike for us today.

The central figure is the personification of Peace, who suckles a small
child representing Prosperity. Behind her, Minerva, the goddess of wis-
dom, fends off the heavily armoured god of war Mars, who threatens the
idyll with a fury in his retinue. Two maidens are borne in on from the

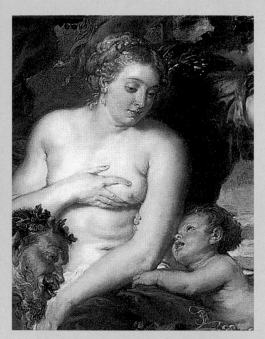

right on a cornucopia overflowing with fruit, while a leopard stretches out playfully on the ground and a woman on the left brings a bowl filled with gold chalices and jewellery into the picture. The message is clear: peace brings wealth, a good harvest, happiness and harmony.

These days, an alternative interpretation of the female nude is that she is Venus, the goddess of love, or, more generally, a symbol of maternal love. This and the fact that Rubens does not permit adults but only children to approach the cornucopia, while the torch-bearing boy welcoming the girls represents Hymen, the god of marriage, are indications of a universal thought: love, whether between spouses or for one's descendants, is the only soil on which peace can prosper.

The formal arrangement also underlines the message of the work. It is quite clear from the composition that the female figure, whether Peace or Venus, is the focal point around which everything moves. The warm yellows and golds of the peace scene form a striking

contrast to the cold, dirty brown shades of war. It almost seems as if Rubens drew a diagonal line from top left to bottom right in which war and peace are mirrored.

As in the *Madonna in the Floral Wreath*, Rubens succeeded in using a detail to lend the picture personal meaning. The two small girls and the boy with the torch are portraits of the children of Flemish painter Balthasar Gerbier, who lived in England and was Rubens' host during his stay there. For Rubens, this picture certainly meant more than purely a diplomatic present combining art and the political commission he had to complete. It was a personal manifesto expressing not only his hope for an end to war but also the high value he placed on private happiness.

Autumnal Bliss for a Prince of Painters

Retires from politics _ The young Hélène Fourment becomes his second wife and muse _ Paintings for Inigo Jones's Banqueting House _ A new interest in landscape painting _ Purchase of a country seat _ Death of Rubens

Retires from politics _ His failure in reconciling the northern provinces and the unsettled life that his diplomatic missions entailed wore Rubens down. He was taken aback to find that no recompense for his travel expenses would be paid to him and that his mission therefore constituted a severe loss to him financially. Disillusioned, he decided to turn his back on politics and return to his real vocation of art. After years of mourning his deceased wife Isabella, he also felt ready for change in his private life.

> *"I decided to marry, as I was not yet inclined to live in the renunciation of celibacy. ... I have taken a young woman from a good bourgeois house, although everyone tried to persuade me to marry a lady from court."*
> Rubens to Nicolas-Claude Fabri de Peiresc, 1634

The young Hélène Fourment becomes his second wife and muse _ The bride he chose was Hélène Fourment, the daughter of a respected silk and tapestry dealer from Antwerp. At the date of their marriage (6 December, 1630) Rubens was in his fifty-fourth year and Hélène was only sixteen – the same age as Rubens' son Albert. Such an enormous age difference, even at a time when early marriages were the norm, was most unusual. Rubens made no secret that it was a love marriage. His fondness for the lovely Hélène is evident in numerous paintings he did of his second wife. *Hélène Fourment Pulling on a Glove* probably dates from just after the marriage. It shows the young woman dressed in a fashionable aristocratic velvet gown and wearing a string of pearls and pearl earrings. The dark material of the dress

The artist towards the end of his life

Self-portrait, after 1635, black chalk, heightened with white, 64 × 28.7 cm,
Musée du Louvre, Paris

Hélène Fourment Pulling on a Glove, *c.* 1630/31, oil on panel, 96.6 × 69.3 cm, Alte Pinakothek, Munich

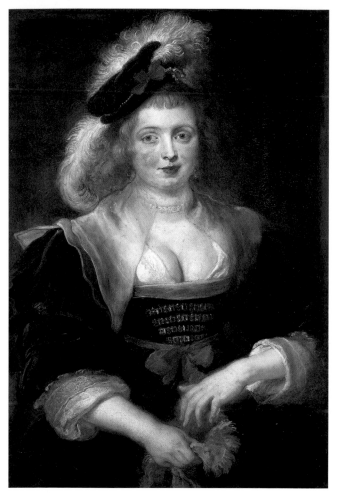

and equally dark background bring out the subject's gleaming, almost transparent skin and her opulent curves. An even more explicit paean to the sensuality of his wife is the famous painting *Hélène Fourment in a Fur Wrap* of around the same time. This painting's intimate character is highlighted by the fact that it is the only one that Rubens

bequeathed to his wife after his death on the condition that it should not be sold. Hélène stands before us clad only in a gold-bordered fur. The gesture of covering herself seems almost casual, as if she had been interrupted while getting dressed or undressed. This intimate picture likewise allows for a mythological interpretation, since Hélène's pose recalls the *Medici Venus*, a famous statue from ancient Rome, while the spring, which Rubens roughly sketches in as the sole background feature, is also part of the Venus iconography. Though far from idealizing her, the *Fur Wrap* records the gaze of the doting husband looking at his wife. For Rubens Hélène was Venus, the goddess of love, incarnate, who reveals herself to him.

His hymn to sensuality was inspired by the goddess of love

Hélène Fourment in a Fur Wrap, after 1630, oil on panel, 175 × 96 cm,
Kunsthistorisches Museum, Vienna
Venus Medici, mid-1st century AD, Height 153 cm, Uffizi, Florence

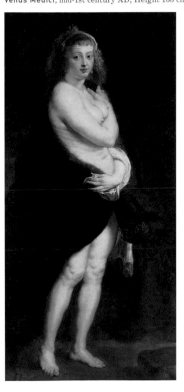

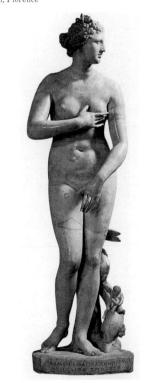

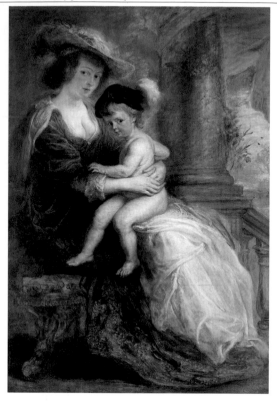

Hélène Fourment with her Firstborn Son, Frans, *c.* 1635, oil on panel, 146 × 102 cm, Alte Pinakothek, Munich

The private happiness with Hélène was blessed with five more children – Clara Johanna (1632), Frans (1633), Isabella Helena (1635), Peter Paul (1637) and Constantina Albertina (born in 1641, eight months after Rubens died). The painter recorded the family idyll in several paintings. One of these, *Hélène Fourment with her Firstborn Son, Frans* of *c.* 1635 is a rather unusual double portrait. The young Frans, who is probably about two, sits in his mother's lap naked except for a hat – echoing the Virgin and Child iconography. Hélène's fine clothing, elegant attitude and the terrace-like setting with the draped column in the background are reminiscent of princely portraits highlighting rank. They are eloquent of the painter's self-assurance as a member of the highest social circles.

Hélène's features turn up not just in portraits but also in pictures of other subject matter. She inspired one of the figures depicted in the *Three Graces*, and the embodiment of a nymph in the *Fête Galante*. In the *Judgement of Paris*, she became the goddess Venus again, who wins the prize for beauty. Her role is quite distinct from that of Rubens' first wife, Isabella. Hélène was not just the caring mother responsible for a large household; she was at the same time the ageing artist's muse, model and fountain of youth.

Hélène Fourment as one of the Three Graces
The Three Graces, *c.* 1635, oil on panel, 221 × 181 cm, Museo del Prado, Madrid

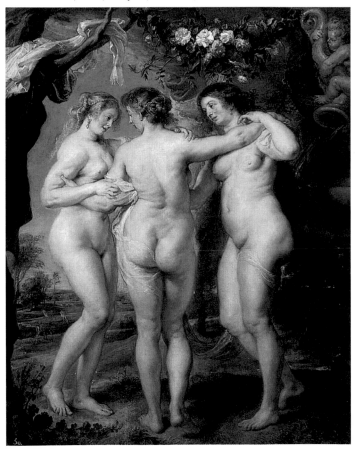

Paintings for Inigo Jones's Banqueting House _ The many contacts that Rubens had made during his political activities earned him a number of major commissions. While he was still at court in England, he was given a contract to provide paintings for Inigo Jones's rebuilt Banqueting House in Whitehall. Begun in 1622, at the tail-end of James I's reign, the building was intended as a venue for important state functions and masques. Rubens contracted to provide nine paintings glorifying the House of Stuart, to go with the splendidly carved ceiling. Rubens set to work on his return to Antwerp, and sent the finished canvases to London in 1634/35. They were installed the following year.

The ceiling of the Banqueting House, a building still used for its original purpose, for state functions, is today the only interior scheme designed by Rubens to have survived in its original form.

Rubens fills the hall

Apotheosis of James I, *c.* 1632–34, oil on canvas, inserted into the ceiling of the Banqueting House, Whitehall, London

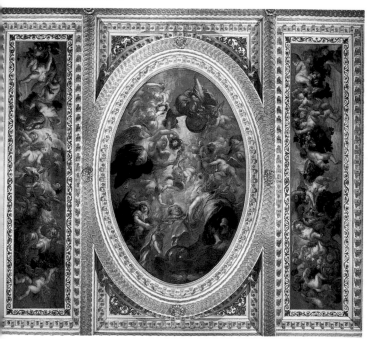

Rubens paints the attrocities of war

Horrors of War, *c.* 1637/38, oil on canvas, 206 × 342 cm, Galleria Pitti, Florence

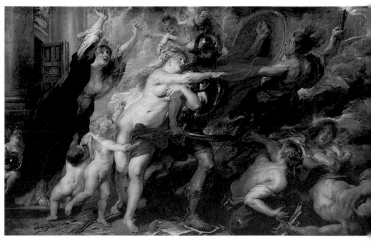

1633 brought the death of Archduchess Isabella. Her successor was Ferdinand, a brother of Spanish king Philip IV. His arrival in Brussels in November 1634 was marked by frenetic celebrations, and a splendid triumphal procession was organized in Antwerp for him as the new hope for the future. Rubens was entrusted with conceiving the street decorations for the state reception in Antwerp. His ingenious programme and the successful implementation of his designs proved once again that the self-assessment he had written in a letter years earlier was not an exaggeration:

> "*My talent is such that no commission has surpassed my desire to set about it, however excessively many objects it may involve.*"
> Rubens to William Trombull, 1621

Although Rubens must finally have abandoned his diplomatic career by the time Archduchess Isabella died, the political situation in Europe continued to worry him. Impressive proof of his profound shock at the never-ending misery of the Thirty Years' War is his picture of the *Horrors of War*, which he painted *c.* 1637/38 for Ferdinand de' Medici. One should note in this context the tone of resignation. Whereas in the earlier *Allegory of Peace* harmony and confidence

Crucifixion of St Peter, *c.* 1637–40, oil on canvas, 310 × 170 cm, Church of St Peter's, Cologne

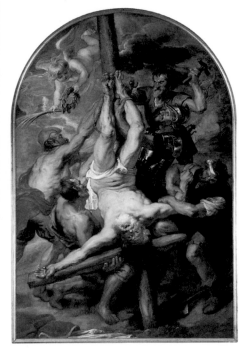

ruled, now war and all its horrors clearly has the upper hand. In a letter to Ferdinand's court painter Justus Sustermann, he said of his work:

> *"The main figure is Mars, who has left the open temple of Janus and marches up and down with his shield and blood-stained sword threatening the nations with still worse disasters. ... That grief-stricken woman in the black robe and torn veil ... is unhappy Europa, who has suffered rapine, humiliation and misery for so many a year."*
> Rubens, 1638

A further commission took Rubens back to Cologne, the city of his childhood. Banker and collector Eberhard Jabach wished to donate an altarpiece to the Church of St Peter's, where Jan Rubens is buried,

and the request was passed to Antwerp. Rubens' suggestion of St Peter the Martyr as its subject found approval. The question as to whether the kind of brutal scene that Rubens came up with is what the patron in Cologne expected must be left unanswered.

A new interest in landscape painting _ The painter's late work is notable for a genre that had played a subordinate role in his oeuvre hitherto, landscape painting. Whereas representations of nature had previously been limited to backgrounds and were left either to assistants or specialists specifically employed for the purpose, he seems to have discovered landscape for himself as he grew older.

Purchase of a country seat _ In 1635, he bought himself a country house just outside Antwerp called the Château de Steen or Het Steen. There he set up a small studio and spent more and more time outside the city. The two works *Landscape with Het Steen* and *Landscape with Rainbow*, both of *c.* 1635–38, were painted presumably as companion pieces, and show how masterly Rubens could capture the atmosphere of different times of the day – morning with Het Steen

Landscape becomes a favourite genre for Rubens

Landscape with Rainbow, *c.* 1635–38. Oil on panel, 135.5 × 233.5 cm.
Wallace Collection, London

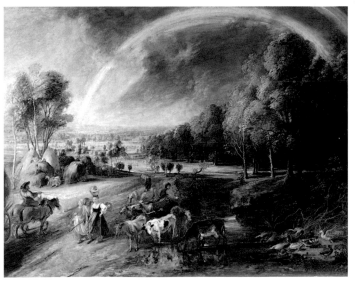

Landscape with Het Steen, *c.* 1635–38, oil on panel, 131 × 229 cm,
National Gallery, London

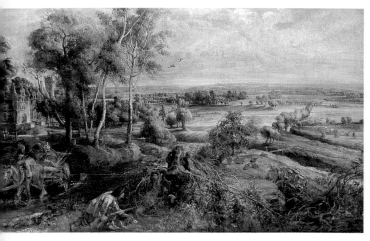

and late afternoon with its counterpart. The rustic world of peasants,
familiar to him from his days in the country, exercised a similar fasci-
nation for him as for Pieter Bruegel, his great fellow countryman and
sixteenth-century fellow artist. Picking up the Bruegel tradition of

The peasant world as a symbol of joie de vivre

Flemish Kermess, *c.* 1630, oil on panel, 149 × 261 cm, Musée du Louvre, Paris

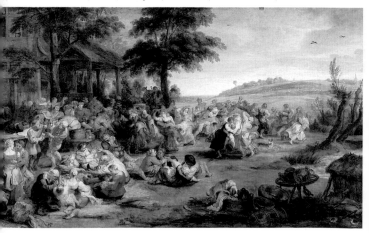

peasant scenes, Rubens began to paint similar genre scenes. His *Flemish Kermess* of *c.* 1630 is a vivid reflection of the rustic *joie de vivre*, boozing, flirting and frenetic dancing that went hand in hand with the intoxicating merry-making of the rural population.

The painter's work of the last decade culminated in the *Love Garden*, which dates from between 1632 and 1634. Once again, it is a declaration of love to Hélène. Rubens paints himself in his personal arcadia, which is populated by countless images of Hélène and putti fluttering merrily hither and thither.

The last declaration of love to Hélène Fourment
Love Garden, *c.* 1634/35, oil on canvas, 198 × 283 cm, Museo del Prado, Madrid

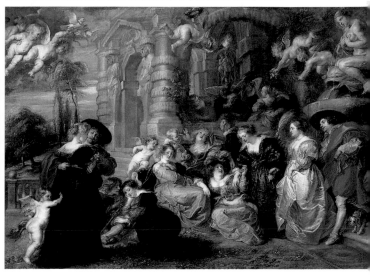

Death of Rubens _ Despite the second spring he enjoyed with Hélène, the years prior to his death were not always comfortable for Rubens. Probably since the late 1620s, he had been constantly plagued by violent attacks of gout that sometimes rendered him incapable of working for days on end. The disease got so bad that in the end his hands seemed crippled and he was no longer able to travel. On 30 May, 1640, Peter Paul Rubens died in Antwerp aged sixty-two.

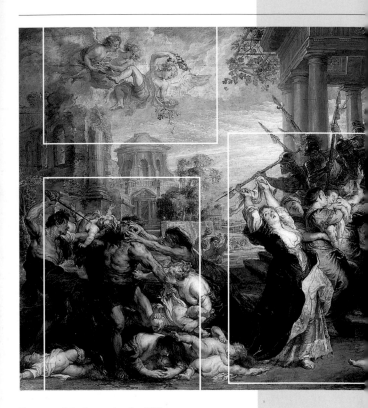

Massacre of the Innocents, after 1635,
oil on panel, 199 × 302 cm,
Alte Pinakothek, Munich

Massacre of the Innocents

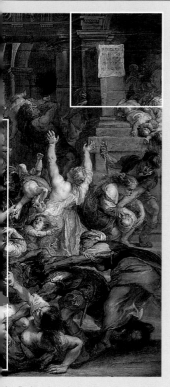

The dramatic rendering of a biblical bloodbath as a symbol of war – Rubens at the height of his narrative art

In his monumental work *Massacre of the Innocents*, which was painted in the second half of the 1630s for an unknown client, Rubens pulled out all the narrative stops. With unsparing realism, he depicts the horrors of the massacre described in the Gospel of St Matthew, when King Herod sent soldiers to Bethlehem. Their orders were to kill all male infants under the age of two, in an effort to ensure that the 'newborn king of the Jews', whose star the Magi had followed, should not survive.

As Rubens paints the story, the king himself is on hand to witness the event. Concealed behind the solid columns of his palace in the twilight, screened from his bodyguard, he can't take his eyes from the bloodbath he has initiated – his orders are nailed to a pillar for all to read. The paradise-like view that opens up between the Classical architecture seems like a mockery in the face of the terrible scenes in the foreground. The angels scatter-

ing rose petals, who at first glance look out of place, are evidence of the general view that the murdered children are to be seen as early martyrs.

Compositionally, Rubens divided the mothers and soldiers involved in the merciless struggle in the foreground into three groups. On the left, two desperate mothers scratch the face and body of one of the soldiers, while another soldier plunges his sword into the chest of a small child. Infant corpses lie on the ground in their own blood. It is noticeable here that even in this late work Rubens was still drawing inspiration from the poses of Classical sculptures he had seen during his Italian trips

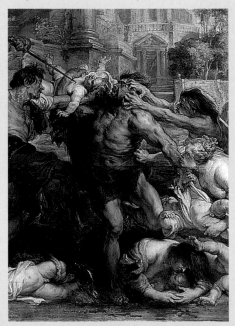

many years earlier. The soldier being attacked by the furious women bears a striking resemblance to the Laocoön group, which strongly influenced numerous artists from the time it was discovered in Rome in 1506. On the right as well, distraught mothers attempt to save their children from certain death. An impenetrable melee culminates in a soldier, who, before the horrified eyes of

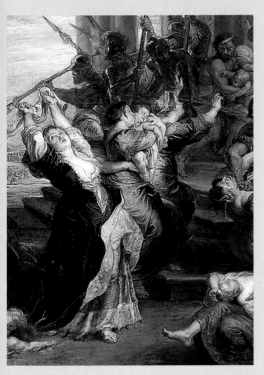

the screaming mother, is about to dash a boy against a pillar. The picture reaches its climax in the solitary female figure at the centre of the picture. Holding up a blood-soaked garment with both hands, her splendid robe almost torn from her body and three mothers behind her in different stages of pain, she is like a memorial into which all the agony is channelled.

No other painting by Rubens displays a comparable spectrum of human suffering. No other compacts so much drama and brutality into a single scene. We may assume that behind the narration of the Biblical story there is another, more personal level for Rubens. In the *Massacre of the Innocents* he distils all his painful experiences of war, bringing together elements from his allegorical war pictures. Especially the isolated woman in the middle is an echo of the figure of Europa from the *Horrors of War*, of whom he wrote that "she has suffered from rapine, humiliation and misery for so many a year." The Bethlehem mothers wear clothes from Rubens' day, while the thugs with their old-fashioned loincloths are more like prehistoric barbarians. The cruel murder of innocents is thus removed from its historical context, and the picture becomes a universal symbol of a continent tormented by terror and sorrow.

Where can Rubens' works be seen?

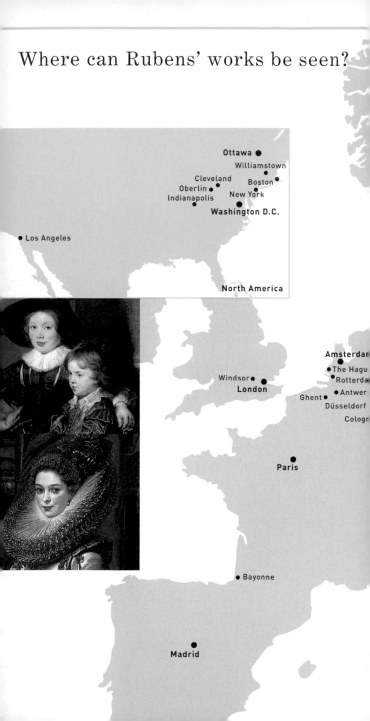

Ottawa ●
Williamstown
Cleveland ●
Oberlin ● ● Boston
Indianapolis ● New York
Washington D.C.

● Los Angeles

North America

Amsterdam
● The Hague
● Rotterda
Windsor ● ● Antwer
London
Ghent ●
Düsseldorf
Cologn

Paris

● Bayonne

Madrid

St Petersburg

●**Berlin**
● Brunswick

● Kassel

● Dresden

Karlsruhe

● Munich ●
 Vienna

● Milan

● Florence

●
Rome

Amsterdam
Rijksmuseum Amsterdam
Stadhouderskade 42
www.rijksmuseum.nl

Antwerp
Koninklijk Museum voor
Schone Kunsten
Leopold de Waelplaats
www.museum.antwerpen.be/kmska/
Rubenshuis
Wapper 9–11
www.museum.antwerpen.be/
rubenshuis

Bayonne
Musée Bonnat
5, Rue Jaques-Lafitte

Berlin
Staatliche Museen zu Berlin –
Preußischer Kulturbesitz
Gemäldegalerie Kulturforum
Matthäikirchplatz 4
www.smb.spk-berlin.de

Boston
Museum of Fine Arts
465 Huntington Avenue
www.mfa.org

Brunswick
Herzog Anton Ulrich-Museum
(Kunstmuseum des Landes
Niedersachsen)
Museumstraße 1
www.museum-braunschweig.de

Cleveland, Ohio
The Cleveland Museum of Art
11150 East Boulevard
www.clevelandart.org

Cologne
Wallraf-Richartz-Museum
Martinstraße 39
www.museenkoeln.de/wrm/

Dresden
Staatliche Kunstsammlungen
Dresden
Gemäldegalerie Alte Meister
Theaterplatz 1
www.staatl-kunstsammlungen-
dresden.de

Düsseldorf
museum kunst palast
Ehrenhof 4–5
www.museum-kunstpalast.de

Florence
Galleria degli Uffizi
Piazzale degli Uffizi
www.uffizi.firenze.it
Palazzo Pitti
Piazza Pitti 1
www.sbas.firenze.it/musei
/pitti2.html

Ghent
Museum voor Schone Kunsten Gent
Citadelpark
www.mskgent.be

The Hague
Koninklijk Kabinet van Schilderijen
Mauritshuis (Royal Picture Gallery)
Korte Vijverberg 8
www.mauritshuis.nl

Indianapolis
Indianapolis Museum of Art
4000 Michigan Road
www.ima-art.org

Karlsruhe
Staatliche Kunsthalle Karlsruhe
Hans-Thoma-Straße 2–6
www.kunsthalle-karlsruhe.de

Kassel
Staatliche Museen Kassel
Gemäldegalerie Alte Meister
Schloss Wilhelmshöhe
www.museum-kassel.de

London
Banqueting House
Whitehall
www.hrp.org.uk
British Museum
Great Russell Street
www.thebritishmuseum.ac.uk
Courtauld Institute Gallery
Somerset House
Strand
www.courtauld.ac.uk
National Gallery
Trafalgar Square
www.nationalgallery.org.uk

National Potrait Gallery
St. Martin's Place
www.npg.org.uk

The Wallace Collection
Hertford House
Manchester Square
www.wallacecollection.org

Los Angeles
The Getty Center
1200 Getty Center Drive
www.getty.edu

Madrid
Museo Nacional del Prado
Paseo del Prado 8
www.museoprado.es

Museo Thyssen-Bornemisza
Paseo del Prado 8
www.museothyssen.org

Milan
Biblioteca Ambrosiana
Piazza Pio XI 2
www.ambrosiana.it

Munich
Bayerische Staatsgemälde-
sammlungen, Alte Pinakothek
Barer Straße 27
(Entrance: Theresienstraße)
www.pinakothek.de

New York
The Metropolitan Museum of Art
1000 5th Avenue at 82nd Street
www.metmuseum.org

Oberlin, Ohio
The Allen Memorial Art Museum
Oberlin College
87 North Main Street
www.oberlin.edu/allenart/

Ottawa, Ontario
National Gallery of Canada
380 Sussex Drive
www.national.gallery.ca

Paris
Musée du Louvre
34–36, Quai du Louvre
www.louvre.fr

Rome
Galleria Borghese
Piazzale Museo Borghese 5
www.galleriaborghese.it

Pinacoteca Capitolina
Piazza del Campidoglio 1
www.comune.roma.it/
museicapitolini/pinacoteca/

Rotterdam
Museum Boijmans Van Beuningen
Museumpark 18–20
www.boijmans.rotterdam.nl

St Petersburg
State Hermitage Museum
34 Dvortsovaya Naberezhnaya
www.hermitagemuseum.org

Vienna
Albertina
Albertinaplatz 1
www.albertina.at

Gemäldegalerie der Akademie der
bildenden Künste
Schillerplatz 3
www.akademiegalerie.at

Kunsthistorisches Museum
Maria Theresia-Platz
www.khm.at

Liechtenstein Museum
Die fürstlichen Sammlungen
Fürstengasse 1
www.liechtensteinmuseum.at

Washington D.C.
National Gallery of Art
Constitution Avenue
between 3rd and 9th Streets NW
www.nga.gov

Williamstown, Massachusetts
Clark Art Institute
225 South Street
www.clarkart.edu

Windsor
Windsor Castle
The Royal Collection
www.the-royal-collection.org.uk

More about Rubens: a selection of books on the artist and his work

Literature on Peter Paul Rubens could fill quite a number of book-shelves; most of the publications, however, are relatively old.

Among the **standard works** on Rubens are: Jacob Burckhardt, Recollections of Rubens (English translation by H. Gerson), London 1950 and the Rubens expert Martin Warnke's book Peter Paul Rubens. Leben und Werk, Cologne 1977, in which Rubens' work is analysed within its personal, political and religious contexts.

Monographs with good-quality illustrations and interesting texts include: Christopher White, Peter Paul Rubens. Man and Artist, New Haven/London 1987 and D. Bodart, Rubens, Milan 1981. A well-re-searched but easy-to-read introduction to the artist seen within an (art)-historical context is: Kristin Lohse Belkin, Rubens, London 1998.

All those who want to delve deeper into Rubens' œuvre should refer to the Corpus Rubenianum, a 26-volumed **catalogue raisonné**: Corpus Rubenianum Ludwig Burchrad, An Illustrated Catalogue Raisonné of the Work of Peter Paul Rubens Based on the Material Assembled by the Late Dr. Ludwig Burchard in Twenty Six Parts, London 1968 (first vol.). The volumes that have been published so far are: 1–3, 7–9, 10, 13, 16, 18, 19, 21, 23 and 24 and cover different aspects such as the saints, land-scapes, or copies of works from Antiquity. Julius S. Held, The Oil Sketches of Peter Paul Rubens. A Critical Catalogue, 2 vols, Princeton 1980 is equally indispensable.

The artist's own writings provide a glimpse of his thoughts and ideas: Original Unpublished Papers Illustrative of the Life of Sir P. P. Rubens as an Artist and a Diplomatist, W. N. Sainsbury (ed.), London 1859 and The Letters of P. P. Rubens, R. S. Magnum (ed.), Cambridge, MA 1955.

Specific areas of Rubens' artistic output are the subject of numerous publications such as: Peter Paul Rubens. A Touch of Brilliance. Oil Sketches and Related Works from The State Hermitage Museum and the Courtauld Institute Gallery, Munich et al., 2003, which documents new research into Rubens' preliminary sketches for major works and L. Burchard and R.-A. d'Hulst, Rubens: Selected Drawings, 2 vols, London/New York 1959. L. Vergara, Rubens and the Poetics of Landscape, New Haven/London 1982 and Christopher Brown, Rubens' Landscapes: Making and Meaning, New Haven 1988 place landscapes within the framework of various phases in the artist's life and his other paintings, comparing them to landscapes by other European painters from the fifteenth to the eighteenth centuries. W. Stechow, Rubens and the Classical Tradition, Cambridge, MA 1968 focuses on paintings inspired by works from Antiquity whereas John R. Martin's book Rubens: The Antwerp Altarpieces, London 1969 concentrates on one specialist field.

Of the few **catalogues** printed in English, the publication edited by the Trustees of the British Museum in London on the occasion of an exhibition held at the Department of Prints and Drawings can be recommended for in-depth information on this area of the artist's work: Rubens: Drawings and Sketches, London 1977.

Peter Paul Rubens' Self-Portraits

Rubens devoted a large part of his work, especially in the late years, to recording his family. He painted numerous intimate portraits and produced studies and drawings of his wives and children that reappear in his paintings – even in commissioned works. In his œuvre, there is no trace of the obsessive interest in his own person such as distinguished his contemporary Rembrandt, who depicted himself at all stages of his life. The few self-portraits that Rubens did paint tend to reflect more his marked awareness of rank or document important events in his life.

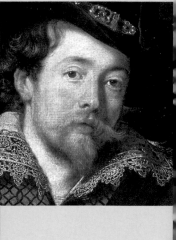

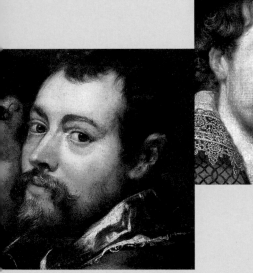

Rubens among his Mantuan Friends (pp. 5, 11) was painted in Italy shortly after his reunion with his favourite brother, Philipp. It shows the brothers with the scholar Justus Lipsius, and illustrates the artist's view of himself as a cultured man who keeps company with equals.

Rubens and Isabella Brant in the Honeysuckle Arbour (p. 19) shows him with his new wife shortly after their wedding – a young, ambitious burgher of Antwerp with a living to make.

It is noticeable that Rubens never painted himself in a professional capacity, i.e. equipped with an easel, canvas and brush, as was very commonly done by other painters of the day. He always appears to us in elegant dress, with the bearing of an aristocrat. The same is true of the self-portrait painted in the first half of the 1620s after considerable pressure was put on him by Charles I, who wanted it for his collection and who later developed a cordial friendship with Rubens (p. 33). The artist wears a broad-rimmed hat, which covers the early signs of the receding hairline we know from other portraits.

Only in the last years of his life did Rubens the painter turn a more open and unsparing eye on himself. In an impressive chalk drawing

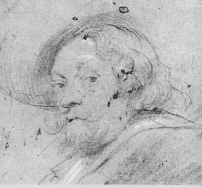

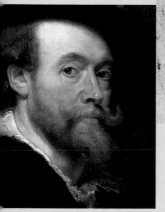

p. 47) dating from 1635–40, he looks tired and worn out. By then he had already given up his political work and remained for days on end in his country house at Het Steen. His hopes for an end to the long years of war in Europe and for the reunification of his divided home-land had come to nothing, and gout, which had tormented him for a decade, worsened with each attack. This is probably the last of Rubens' self-portraits.

Allegory A visual representation of abstract concepts, such as faith, power or wisdom. The principal device used is personification, though fixed attributes are often introduced to help identify the concept being personified.

Attribute Objects or entities (e.g. lily, deer) associated symbolically with mythological, religious and historical figures to help identify them or to represent an abstract concept associated with them (e.g. purity). The lily, for example, is an attribute of the Virgin.

Cartoon A drawing done with chalk, charcoal or pencil on thick paper in preparation for a fresco or other large-scale representation, such as a tapestry or a mosaic.

Counter-Reformation The Catholic Church's belated reaction to Martin Luther's Reformation. Specific counter-measures were agreed by rulers and clerics at the various Councils of Trent between 1545 and 1563, and in some cases they still apply today. The frontline army included orders such as the Jesuits and Theatines, which quickly gained great influence.

Emblem A combination of picture and text. In the original form, a picture (imago) is linked with a motto (inscriptio) and an explanatory epigram (subscriptio). The three elements together constitute a powerful carrier of meaning. Emblems were developed by the humanists of the Italian High Renaissance, though they incorporated elements of late medieval allegory and the Early Renaissance.

Guild Exclusive trade, commercial or professional organization in medieval northern Europe, first evolved in the eighth century. Particularly important were craft guilds, such as those for weavers and

stonemasons. Membership of a guild was compulsory for practising a craft, and in return the guild provided protection and support. Painters' guilds were traditionally named after St Luke, who allegedly painted an image of the Virgin and Child.

Reformation Triggered off by Martin Luther's Ninety-five Theses pinned on the door of the palace church in Wittenberg in 1517. Directed against the Church's authority and abuse of power, the theses argue for a return to pure faith and study of the Bible. Whereas moderate reform took root in Germany as Lutheranism, in the Netherlands the more extreme Calvinism gained many supporters.

Stoicism (from the Greek *stoa* = covered hall or portico used as a meeting place). A system of philosophy developed by Zeno of Citium, Cyprus. The school (fl. 300 BC) used to foregather in a stoa in Athens, hence the name. Stoics define philosophy as the corpus of knowledge about divine and human things, subdivided into logic, physics and ethics. Stoicism later became the leading philosophy in the Roman Empire, with Seneca (d. AD 65) as its most important representative.

Triptych Three-part picture. A type of medieval altarpiece consisting of a centre panel and two wings, often attached by hinges.

© 2004 Prestel Verlag, Munich · Berlin · London · New York

Front cover: **Rubens and Isabella Brant in the Honeysuckle Arbour**
(detail), c. 1609/10, see also front flap and p. 19
Back cover: **Boy with a Coral Necklace** (detail), c. 1619, see also p. 24

Photographic credits: cover, pp. 18, 24 bottom, 25 l., 26–28, 34, 37, 48,
50, 58/59: Artothek, Weilheim _ p. 6: Haboldt & Co., Paris _ pp. 7, 9 r.,
10, 21 top, 35, 47, 56: Louvre, Paris _ p. 8 l.: Metropolitan Museum,
New York _ pp. 8 r., 20: Rubenshuis, Antwerp _ p. 9 l.: The Hermitage,
St Petersburg _ p. 11: Wallraf-Richartz-Museum, Cologne _ pp. 12, 51,
57: Prado, Madrid _ p. 13: Accademia, Mantua _ p. 14: National Gallery
of Art, Washington D.C. _ pp. 21, 22: Antwerp Cathedral _ pp. 24 top,
40 l.: Albertina, Vienna _ pp. 25 r., 42/43, 55 top: The National Gallery,
London _ p. 33: The Royal Collection, Windsor Castle _ p. 36: Clowes Fund
Collection, Indianapolis _ pp. 38, 49 r.: Galleria degli Uffizi, Florence _
p. 39: The Collection of the Princes of Liechtenstein, Vaduz _ p. 40 r.:
Musée Bonnat, Bayonne _ p. 49 l.: Kunsthistorisches Museum, Vienna _
p. 52: The Banqueting House, Whitehall, London _ p. 53: Galleria Pitti,
Florence _ p. 54: St Peter's Church, Cologne _ p. 55 bottom: The Wallace
Collection, London

The Library of Congress Cataloguing-in-Publication data is available;
British Library Cataloguing-in-Publication Data: a catalogue record
for this book is available from the British Library; The Deutsche
Bibliothek holds a record of this publication in the Deutsche National-
bibliografie; detailed bibliographical data can be found under:
http://dnb.ddb.de

Prestel Verlag, Königinstrasse 9, 80539 Munich
Tel. +49 (89) 38 17 09-0; Fax +49 (89) 38 17 09-35

Prestel Publishing Ltd., 4 Bloomsbury Place, London WC1A 2QA
Tel. +44 (020) 7323-5004; Fax +44 (020) 7636-8004

Prestel Publishing, 900 Broadway, Suite 603, New York, NY 10003
Tel. +1 (212) 995-2720; Fax +1 (212) 995-2733

www.prestel.com

Series concept: **Victoria Salley**
Graphics: **www.Lupe.it**, Bolzano, Italy

Editorial direction: **Christopher Wynne**
Translated from the German by **Paul Aston**, Italy
Copy-edited by **Michele Schons**, Gröbenzell
Designed and typeset by **zwischenschritt** and **a.visus**, Munich
Originations by **ReproLine mediateam**, Munich
Printed and bound by **Gotteswinter**, Munich

Printed in Germany on acid-free paper
ISBN 3-7913-3076-4